Exmoor Tales
Autumn

Edited by Sarah Dawes

Layout and cover design by Oliver Tooley

Interior font - Garamond
Title font Black Chancery and Baskerville Old Face

Published by Blue Poppy Publishing

ISBN: 978-1-83778-001-3

Exmoor Tales Autumn

A Personal Journal of Life on Exmoor

Ellie Keepers

Contents

For Ollie, Lexie and Zack
The brightest stars in the night sky.

The Cottage

The cottage, nestled in the stunning Exmoor countryside, is surrounded by beech trees and hedges. She sits up high on the hill and overlooks meandering fields, woodland and the most beautiful valley you ever did see. From her viewpoint, protected from all but the worst of the weather that England can throw at her, she is privy to the secret lives of the red deer and other wildlife that Exmoor is so famous for. How privileged am I, the inhabitant of the cottage, to have a front seat view on my doorstep?

She was always meant to be mine, this cottage. She protects, she nurtures, she survives on love, and she holds secrets – secrets from the past that give her a character so obvious to all who set foot over her threshold. There is a peacefulness about her that many have commented on over the years. As I stand in the centre of the cottage I can feel the blood of her running through the walls; I hear her heart beating. My bones are her bones. She is small in stature, but big in heart.

Sometimes I leave the cottage for a while and take myself off and over the moor, be it on foot or on four

wheels. I am lucky enough to be able to go for the sheer pleasure of being outdoors. Sometimes I see a special something that I can hold as a memory, to treasure in years to come, and sometimes all I see is the stunning beauty before me. Yet that is enough for me. The absolute joy of being out on the moor in glorious sunshine, howling winds, torrential rain or a mist that blanks out the world in front of me, coupled with the welcome from the cottage on my return, is second to none.

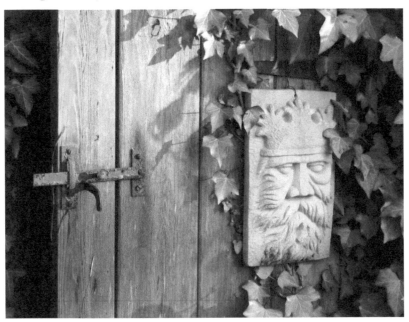

The cottage has a woodburner, which brings the front room to life when the Exmoor mizzlies are in evidence. I sit at the hearth, laying the starter and lighter sticks on the fire, and find myself close to my mum. As I watched her lay the fire when I was a child, so I do it myself now. As the fire burns and I stoke it up with logs, my dad is close

by. As I sat with him as a child, watching him build the fire to keep us all warm, so I do the same now. Both my parents have passed, yet the cottage brings them to me every day by way of the woodburner. In the winter months a large pan sits atop the fire, containing a hearty casserole that simmers gently throughout the day. On these days, the cottage welcomes me home with the aroma of a ready-made meal, coupled with the smell of smouldering beech logs.

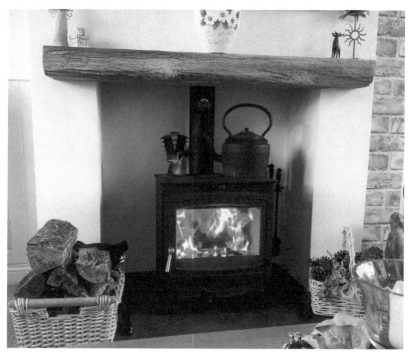

Warmth, a meal, a home – these are simple pleasures in life and I am a lover of simple pleasures.

So it is from the cottage, my cottage, with her Exmoor walls and wild garden, that I will be penning my blog: thoughts, memories and snippets from my ventures and the daily grind that make my life here on Exmoor so very, very special.

Autumn Thoughts

Autumn is wrapping its cloak of colour around Exmoor. The leaves are turning and the hips and haws are prevalent on the trees and shrubs. The season draws some of us indoors to prepare for the winter months to come. Others it entices outside to go wander the places on the moor that they hold close. There they will find a different picture to that of just weeks ago, in our ever-changing landscape. Exmoor is taking on the autumn tinge and as the sun sets at the end of each day the warm orange glow makes that tinge even more vibrant. That, in itself,

reminds us that our daylight hours are becoming fewer as autumn takes hold.

Autumn evenings see the sun hanging low in the sky, and the view from our bathroom window is spectacular. Clear glass allows rays of late sunlight to beam into the small bathroom. It causes dappling shadows, of the leaves of a beech tree outside, to dance like large, dark raindrops in the shimmering sunlight, right across the bathroom wall. As a baby, our grandson would be fascinated by the movement of the leaves' shadows: it's entrancing and quite magical to watch. Like our grandson, I find them fascinating too but also thought provoking. The sunlight and shadows have always reminded me of the light and shade in life, and of that in the changing of the seasons. All that from a bathroom wall and dancing shadows.

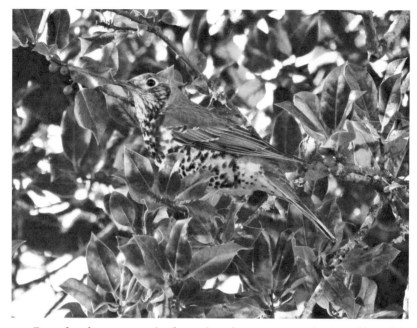

Our bathroom window in the cottage is small, with clear glass and a beam across the top. It looks out over the moorland and I can see the weather coming from way across the moor. It is a source of constant interest, whatever the season. The window is nearly always open. From here I can hear the birdsong, smile at the blue tits, who come and peck around the wooden frame, and nod to the chaffinches who will come to feed from the sill. Sitting right outside is a beautiful old holly tree. Its gnarled appearance only adds to its already strong character. There is a terracotta angel placed half way up this tree of ours; the tree deserves the company. Our angel is partly hiding in the ivy that climbs and wraps itself around the trunk. It's our holly-and-ivy tree. As berries appear on the topmost branches, a mistle thrush will clatter down and

greedily feed on them, giving out a rattling call as it lands. Sometimes a blackbird will interrupt the dining session but doesn't stay long; it seems the thrush has first dibs on the feeding tree. They are so close, I could reach out and touch them and I feel lucky to be able to have the birds nearby and to have a tree that just keeps giving.

The turning of the season sees nature providing, so that the wildlife has sustenance throughout the coldest of months. There are many juicy, plump berries this year,

which in folklore heralds a cold winter. I've seen it before and I don't doubt it for a moment. Now it's rutting season for the red deer, exciting times for those of us who are able, and feel the need, to wander the moor. We feel lucky that we're able to share what we see, along with others, through our photographs and our words. After all, we don't all live in this stunning place and we're not all able to get out there, as much as we'd like to. Conditions can be awful at times but we've never minded what presents itself up on the moor during the autumn months. We take it all: rain, mist, winds, dampness, the mud, puddles and boggy ground. If we didn't venture out, then we'd never see the treasures that Exmoor gives us. Boots on, warm

socks and waterproof backsides and we're away, over the fields and through the woodland to wait and to watch for the majestic stags and their hinds.

Today, although slightly damp, the mists are rising as the sun is trying to break through. It's an uphill climb from the cottage to the gateway where we're headed, and it's a path we've trodden many times before. Hedgerows hang with cobwebs, laden with morning dew, the droplets shining in the weak, early sunlight – always a stand-alone beauty, in my eyes.

Crossing two or three soggy fields, where sheep are grazing along the hedgerows, we find ourselves down in a dip in a corner. Here is where pasture meets woodland. The hedgerows hereabouts were full of bountiful blackberries a few weeks ago. They are now in my freezer after a fruitful and frantic picking during the warmer days of late September. Thoughts of blackberry-and-apple crumble and pies make our mouths water, especially if there's a dollop of clotted cream going spare. Pleasures to look forward to, and given up by the moor.

I think back to how it used to be when I was a child, when my own mother would task herself with making chutneys, jams, and pies with fruit picked from the hedgerows of Kent. There were no freezers and our pies and crumbles were freshly made each day, with the kitchen being the heart of our home.

While chatting about our blackberry-picking exploits and injuries, and treating ourselves to a Fudge bar, we

push on, eager to reach our destination and a warming cup of coffee. Down in the tight corner of the field, a quick look about us as we climb the rickety stile, over the barbed wire, and trundle down the pathway and into the wood. Here, we are walking in the footsteps of the deer. These are their paths we wander and we know them well. Criss-crossing over the woodland, the floor of which is covered with rich, green, spongy moss, dried twigs and

branches, the paths and trails lead us to where we need to be. However, under the canopy of trees, leaves beginning to yellow as autumn takes its hold, we need to divert from the path. The moss keeps our footsteps silent, the twigs not so much, and we have to pick our way carefully to our resting place.

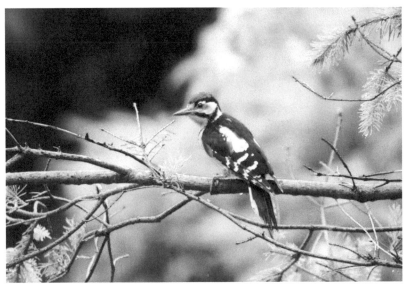

A woodpecker calls in the distance, its rapid peck vibrating in the depths of the woodland, and a robin sings its melodic, velvet song, which seems to be on repeat. Apart from this, the wood is quiet, the trees standing stately in the last of the morning mist, which is slowly lifting. After around a forty-five-minute wander, we reach an ancient hedgerow and bank covered in low-lying, fallen branches and ferns. To one side we have a woodland of native trees, to the other, open pasture with good, close

cover for the deer. It's here that we'll halt our walk and wait, as we've done on so many occasions before.

Being able to observe the red deer at close quarters and to watch their patterns is, for us, the ultimate treasure on Exmoor. Patience is an absolute virtue and, when it comes to waiting for these amazing creatures to show themselves, you need patience by the bucket load; but it's well worth the wait when they eventually appear. They emerge silently, one by one, from the cover of the trees and we never tire of the sight of them. It's the things that money cannot buy that give us the most pleasure and which make us smile. It's always been that way with us.

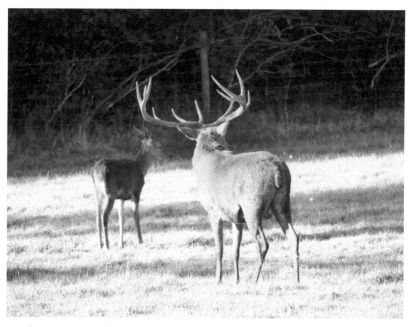

Autumn, whether you choose to stay in or venture out, heralds the end of summer and the onset of winter. It

nudges the wildlife to take stock and gives creatures the bounty that their bodies will need when the cold sets in. It reminds us that we have to ensure a well-stocked log store and an abundance of starters and lighters, all in readiness for the changeover that's nearly upon us. The changeover, when the pattern of my day alters from warm, summer mornings to chilly starts, from having the luxury of my morning coffee in the garden, to having to lay a fire first thing.

Having fulfilled our morning's mission, and cleaned out our supplies, we carefully and quietly retrace our steps through the woodland trails. It feels good to be on our feet again and moving through the trees towards the cottage. There's the promise of a very late lunch and fresh coffee on the cards and our feet quicken as we reach the fields. Making our way back down the hill, (trundling along because it's one of those slopes) there is the distinct smell of woodsmoke permeating the air, coming from the cottage chimney. It's a smell we love; it evokes memories of a childhood long gone: crisp leaves, damp lanes, misty mornings and that woodsmoke smell. We round the bend in the lane and see wisps of silver-grey gently curl into the air behind the trees, and we know we are home. There is no casserole cooking on the woodburner today but, nevertheless, it is still home. It's early autumn, the turning of yet another season. I always feel that the passing of the seasons gives a rhythm to my life here on Exmoor and, in that, I know I'm not alone.

Autumn Red Deer Adventure

It's been quite a week at work for one of us; time to blow some cobwebs away. Falling asleep to the sound of the stags roaring is always a pleasure, and one we will never shut out. Last night was no exception. Our small window is always left ajar during rutting season so that we don't miss a thing. During the daylight hours we can see the deer, a couple of fields over, from our bedroom window. They get slightly closer to the back window, although, to our knowledge, we've only ever had the beautiful hinds visit in that field, never the stags. However, when the inky blackness falls over the moor, there's no hope of seeing anything. It's the knowing the deer are there, though, that's what counts.

During the night hours the tawny owl will call out. Their hunting screech, eerie in the darkness, is somewhat comforting to hear. The owl and its mate call backwards and forwards and the tu-whit-tu-whooing is so loud and distinct on occasions that I'm absolutely sure one of them is sitting in the beech tree across the lane. It's quite an orchestra out there sometimes. Again, no point trying to

look. We may as well stay tucked up under our duvet and enjoy the music of the moor.

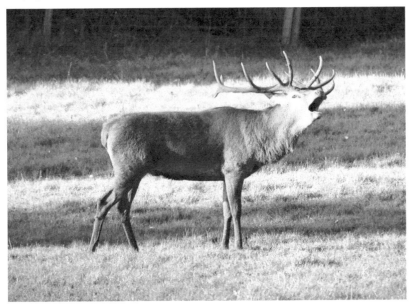

Waking from a sleep punctuated by the roaring stags, it's obvious that the day is going to be a clear one. Across the moor hovers a mist. It will lift in time; breakfast will see it gone. With a cuppa in hand, we set to with eggs and bacon, and granary toast and marmalade, while watching the deer from the kitchen window. Perched on our stools, looking out over the hills, this is one of our favourite times of the day. We could sit forever, but the moor is beckoning us outside. So, breakfast done, dishwasher loaded, we grab what we need and are out the door into the early-morning air.

Today is one of those days when we're off to see the red deer rutting. On Exmoor it's an exciting time of year

and so very much a part of this stunningly beautiful place. As autumn moves in, so too do the majestic stags, holding court over their harem of hinds and battling each other in eye-watering clashes. First we have to locate the deer and we find ourselves walking a good two miles across the moor, cameras and binoculars slung across us. We know exactly where we're headed for – it's finding the best route there that's the problem. Crossing country isn't easy when you have to keep an eye out for rutting stags and their herds. It also isn't easy when you have to look forward, forever watchful, and not down at the bumpy and uneven terrain that you're crossing. In time, we reach our destination and, duly hidden, wind in the right direction, camo head-nets on, we settle down for a wait, which could be some time. We have crossed dew-covered fields and a woodland, just touched by autumn. We have traversed hills and wooded combes, dripping in the colours of the moorland. Now for a coffee and a sit down: the wait is on.

We have come to watch the rut, as we do every year. Four stags can be heard roaring around us, but one roars louder than the rest. It is like being in a *Jurassic Park* film. With the roaring echoing through the trees, it is noisy: extremely noisy. We know we are relatively safe where we are but the close proximity of the stags' roaring has our hearts racing. It is quite unsettling but exciting at the same time. As the roaring becomes clearer and echoes less, we know one of the stags is heading out of the woodland and,

hopefully, towards us. We hold our post and do some more waiting.

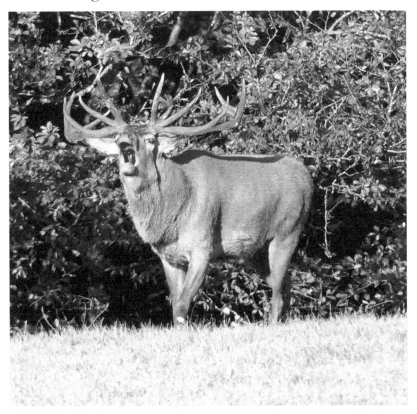

Eventually they come: a lone pricket, seven hinds, a youngster, four more hinds, and then the star of the show – and he doesn't disappoint. At this juncture, we are about forty metres away, and we watch as he answers the roars of those stags calling from the woodland. This stag means business and we have a front row seat. Thankfully we are hidden in a hide, several feet above the ground. It is atop an ancient banked hedgerow, surrounded and encompassed by beautiful beech trees and hedging, and it

is completely hidden. Pill box windows are softened by overgrown foliage, which sways in the wind. It's dark but dry and warm; we know that we are very fortunate and that we have a safe escape route. If it weren't for this hide we would not be venturing anywhere near the stags today. We love to watch nature but we're not for putting ourselves in danger.

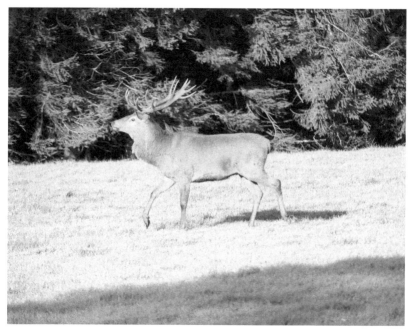

The first stag is joined by another, which is slightly smaller. He appears from the right-hand side of the field, roaring. They eye one another up but they turn and walk away from each other as they continue to roar in turn. If either one of us had been in the smaller stag's shoes, we would have left by now but, no, this one's going nowhere. The larger stag begins to repeatedly rub his head and

antlers on the ground, making scent marks and adorning his antlers with small clumps of vegetation to make himself appear larger than he is. The smaller stag stands, still as still. They roar again and both begin to walk straight towards our hiding place, parallel and several metres apart.

It is all quite menacing and eerie, as the roaring has now stopped. It is as if it has been choreographed, like something from *Strictly Come Dancing*. As they continue their walk towards us, staring straight ahead, weighing each other up, they eventually disappear from view, directly under the hide. For a very split second, we think that maybe we aren't in the best place, our minds playing tricks on us, because the situation is quite intimidating. But, thinking logically, we are safe and we stay put, holding our breath. We didn't ever think that we'd be this close to a stag today; it's a huge field that we know extremely well and, in all the years we've used it, we have not seen the deer as close as this to the hide.

Despite knowing they are just underneath us, when a huge roar comes out of nowhere I almost leave the floor, heart in my mouth. That was loud! Together, and in complete unison, they turn and begin the same walk back whence they came, only to turn once more. For all the world it looks as if they are performing the tango – I kid you not – such is the strutting and staccato movement of both animals. After a quick weighing-up, checking each other out, and a couple more warning roars, they start their second parallel walk towards us, slow and sure.

There is a whole lot of testosterone in that field right now and, amazingly, the power emanating from those stags can be felt by us humans. In this moment we feel very small and totally insignificant. We look at each other through our netting headgear, and know we are both thinking the same thing: that we are going to witness something that we've never seen before, in all our years on Exmoor. Knowing we are safe and out of reach doesn't stop the adrenalin pumping and, bodies trembling, we sit tight and we watch.

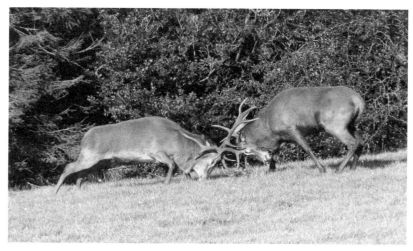

Step by step the two magnificent stags come directly towards us, still walking parallel to one another, as they have been for the last five or six minutes. They cast peculiar, furtive, sideways glances at one another, as much as their antlers will allow, and then they turn. We watch in awe as they rush together, heads down, clashing their antlers with all their might; it is so very swift. The power in their necks and haunches is mind-blowing when seen

as close as this. With antlers locked, the battle begins as they try to unbalance one another, shoving and pushing in their power struggle. It is awesome, and we are shaking. At one point we think the smaller stag is going to take the victory, but it isn't to be. After a few minutes, the larger stag nearly rocks him and, admitting defeat, he turns and retreats. With the victor chasing him off for good measure, the defeated stag makes his way back into the cover, with a token roar.

For such large creatures they sure do move with alarming speed. They plod about, heads heavy with antlers, looking for all the world like they've had a bad day and want to throw the towel in, then – *whoosh!* – they go into turbo mode and show what they're made of. We are so very lucky to have witnessed that magnificent clash. Victory reigns supreme for the larger stag. His breathing is heavy and steam rises from his nostrils as he proudly struts about the field, mouth open, tongue out, holding his noble head high and roaring as we've not heard him roar before. He is magnificent and looks chuffed to bits, as he roars and signals his triumphant display. This carries on for around twenty minutes as he makes his way into his harem of hinds and chases them this way and that.

Once again, the roaring in the woods begins and we wonder if there is to be a rematch any time soon. The stags' testosterone is definitely flowing. We are pretty sure that our adrenalin is pumping as much as theirs and, after some discussion, we decide that we have to make our move and exit the hide as quietly as we can. We've spent

more than three hours hiding and hot food is calling from back home. As we've done on so many occasions before, but with our hearts racing this time, we gather our cameras and binoculars together and quietly close the hatches, shutting out the world of the rutting stags. We pick our time to leave and, observing that the stag has made his way down to the other end of the field, we exit, pushing through the undergrowth of brambles, along our muddy tracks and away from him.

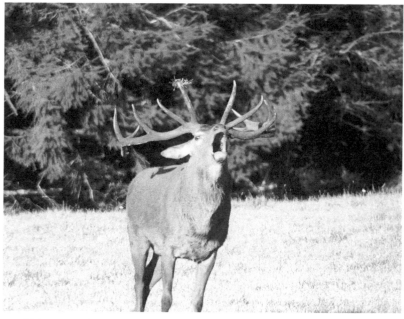

Skirting the field and staying close to the hedgerow – still abundant with wild blackberries – we retrace our steps to home. This is certainly one of those lifetime moments to share with each other and, with our legs still shaking from the experience, we follow the path back to

our warm cottage. As we walk, we laugh about how, just fifteen minutes before the appearance of the herd, we were deciding whether to call it a day and make tracks. The 'just a few more minutes' decision worked a treat for us this time around. Cobwebs blown away? Most certainly. It has been a day to remember, and remember it we will.

Starters and Lighters

What a mucky day. The drizzle, or mizzlies as we call it, is more like a dirty, wet mist and it's the stuff that looks harmless enough but which soaks you through, seeping into your bones. It makes you feel miserable. But there's no such thing as bad weather if you wear the right clothes, and I am garbed up for whatever the weather throws at me. I'm of the opinion that if you don't go out then you can't come home again – and coming home is what it's all about.

I rose early this morning, opened the curtains onto Exmoor and shut them again quickly, after clocking the weather. Berating myself, I pulled the curtains back once more and sat on the window sill, opening the window a little as I did so. At the cottage we have low sills, which I love. They lend themselves perfectly to offering up a place to perch while you pull yourself together. I have been known to take a deep breath, fling back the curtains in an elaborate fashion (one in each hand) to welcome the morning into our bedroom, exclaiming, "Good morning, Exmoor." On one occasion I not only welcomed the Exmoor morning into the bedroom but also the gaze of an Openreach engineer, who was working up a ladder placed against the telegraph pole opposite the cottage. I don't know who was more surprised … but as I was in all my glory, I'd guess it was him. Curtains closed and my modesty hidden, I went in search of a cup of tea.

I've taken to drinking a lemon, ginger, and honey concoction, with a dash of apple cider vinegar to finish it off, as my first drink of the day. It seems to ready me and wake me up, and, touch wood, I've not had anything even resembling a cold or flu for just under four years now. Whether my tea is responsible for that fact, who knows, but I'll continue with it because I enjoy it. Being the heart of the cottage, the woodburner is, first and foremost, the most important thing to get going in the morning. We pride ourselves on a well-lit fire and, for me, my starters and lighters begin that process. Any small sticks and twigs that I can forage from the land are my friends and I will

regularly wander up and down the lane with a basket, collecting them. People have commented that I look like some bent over old witchy-woman straight out of a fairy tale, as I wander the lanes. It makes me smile; if only they knew. My mum was the fire-starter in our house and as a child I would sit with her, watching and learning. My dad, on the other hand, was the stoker. He kept us snug and warm with his huge log-pile concoctions. Together they were a great team and I hold my memories of them close to my heart. From them I learnt so much and I will pass my knowledge onto our grandson, little by little. But I digress …

A couple of nights ago there was a fair old wind blowing over the moor. It always sounds worse than it is

because of the stately beech trees along the lane, taking the brunt of it. However, that wind means there will be twigs aplenty to be picked up. Drizzle or no drizzle, that's what I'm off to do this morning. No matter that they'll be damp or wet, I have a twig store that's ideal for drying them out and I also bundle them with twine, and hang them to dry naturally on my fence posts. If there's one thing I love to see in the garden it's the fruits of my labour hanging from the posts, ready and waiting to keep us warm.

Over across the fields, towards the woodland, is a ready-made supply of sticks and branches. It's a bit of a lug to drag them up the hill but we manage and it's an enjoyable morning's work, when we work together. It really is a two-man job though, so I'll have to walk the hedgerows today, as I'm on my lonesome. My problem is that I do become side-tracked if I spot something interesting and, without my camera, I just stand and record it to memory, to write about in our grandson's diary at a later date. 'Must try harder' should be my motto, but this is Exmoor and there's always something interesting to see.

Enjoying my own company, I'm happy to wander the fields but, as it's rutting season, I am fully aware of the dangers of meeting a stag and his hinds. I enjoy the beauty of these majestic animals, the grace that shines through in even the largest of these stunning creatures. By the same token I smile at the balletic movements of the hinds, as they strut about on full alert, bouncing with finesse as they

decide whether there is a threat about. There is every chance that I could encounter such an obstacle around the fields and, amazing as it would be, I value my safety so much more than witnessing a rutting stag.

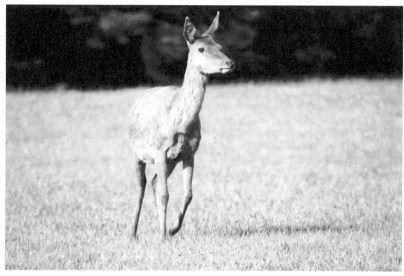

Decision made: off I go to the top hedgerow, nearest the cottage, with its tall beech trees. Several riders on piebald horses pass the old wooden gates as I go to drag my trusty wheelbarrow from the log store. I wave and acknowledge them as they pass, waiting until they're out of sight before moving it. This barrow belonged to my dad and it served him well, although it has a small hole in the bottom. It's been repaired several times and the hole, once the size of a 5p piece has grown to the size of a 10p piece over time. It was pushed along by both my parents; my hands hold where their hands have held and, although I've tried, I cannot part with it. It will collapse soon, I'm

sure, and I'll turn it into a flower container, but until then it accompanies me when I'm dealing with the logs and sticks for the fire.

Through a gate, and onto very wet grass, I push the wheelbarrow. I tell myself it's not worth stopping and leaning on the gate today, but when do I ever listen to my own advice? Of course I'm going to gaze about – even though, through the mizzlies, it's not easy. I've stood at this wooden gate, so full of character, more times than I care to admit. I never grow tired of it and I swear it has a dip along the top where I've stroked my hand along it so many times. From it, the view stretches out for miles over the moor and the valley and it is spectacular. Standing here, I can watch kestrels and buzzards soaring, hovering and hunting as they use the young, slender beech trees as their lookout posts. The pied wagtails are a constant

source of amusement as they bob about and run across the fields and over the manure heap. But, most importantly, I can be privy to the movement of the red deer in the distance. It's a wonderful gateway to life on the moor.

Eventually I tear myself away and, hugging the abundant hedgerow that runs between the pasture and the narrow lane, I set about the task in hand. The banked hedgerow is full of character and wonder, and has been here for hundreds of years. It's made up of twisted, intertwining beech branches and holly, with seasonal wild flowers popping up in between. In the spring and summer months you'll find primroses, snowdrops and a multitude of other wild flowers, and ferns growing in abundance. I'm often to be found out here with my coffee, just standing at the gate enjoying the scene before me. It's the tall beech trees, though, that grow up out of this hedge that will be my giver today. There's plenty about to be picked up; some have moss clinging to them but I'll take anything. I break the twigs into manageable pieces before depositing them into the wheelbarrow; it saves time later and I can fit more in as I gather. I'll have to make several trips but it's a pleasurable chore and the accomplishment and satisfaction of having a stocked starter and lighter store far outweighs the wet and damp that I'm having to endure.

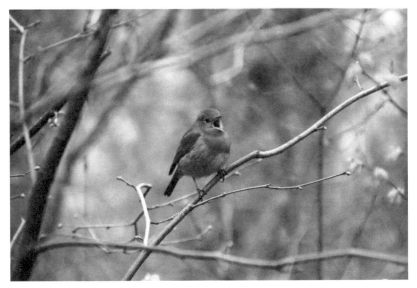

I've never baulked at going out in the worst of weathers and especially love a strong wind. It blows the cobwebs away and makes you feel alive. Not just existing, but truly alive. We never do things by halves here on the moor. If it's windy, then it's windy and blowing a right hoolie. Many times I've returned home from a jaunt across the fields in the wind, stepped over the threshold, shaken my hair from out of my hat and been able to feel my face tingling all over, thanks to the windy weather. It's an amazing feeling.

I've worked my way further down the field now and the roar of a stag rings out from the woodland. For me, it's a signal that enough is enough. I'll leave the fields to the creatures that call this moorland home – after all, time is running out for them; the rut is nearly over. Wheeling my barrow for the final time along the track I've made in

the grass, I secure the gate, and toddle off down the lane. I've not seen a soul or heard a car all the while I've been out and that's just how I like things to be.

Inside the walls of the cottage, the peace will continue and, after shedding my wet clothes in the boot room, I will settle down with a steaming cup of Earl Grey tea and something filling for lunch. I think I deserve beans on toast, which will go down a treat. First, though, I need to replenish the bird table and feeders, as they're a hungry bunch that visit us. I'll then be able to watch them having lunch as I devour my own. It's been a good few hours. A morning's labour and we will reap the benefits in the coming months. Such a simple task but oh so very satisfying. Nature is a giver and today she has given us something for free, once again, and I'm a very happy lady.

Our Healing Moorland

"Tuna or cheese?" calls a voice from the car adjacent to us. It's a maroon RAV4, with a *Take a Break* magazine casually laid on the dashboard. A silver-haired lady makes her way to the front of the car, sandwiches and flask in hand, while her companion peers through the windscreen with a pair of very old binoculars.

Exiting our car with all our normal paraphernalia, we walk together in silence, leaving the ladies to their happy lunch and wishing, in hindsight, that we'd brought a flask with us. Let me explain why we are here (a place we don't normally frequent on a regular basis, but one we enjoy nevertheless). Having taken on some sad news earlier today, we've found ourselves turning to the moorland for some much-needed solace, to calm our disordered thoughts. It doesn't matter where on this varied terrain we wander. What does matter is that we can talk through our sadness or wander along in complete silence, absorbing the peace and calm that we know we will find there.

COVID took the life of one of my husband's dear friends last night and his complete sadness filters through to me, as it should. There will be a time for words, but not

yet. Contemplation and thought come first and what better place to be at one with yourself than somewhere out on the moor – the wilder and more open the better for the moment. Hence we find ourselves here, on this path, simply wandering along. We need space and it's here that we find it.

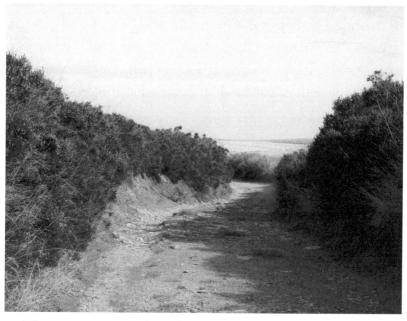

The scene to the front of us is of undulating, patchwork moorland in greens and browns. It looks towards Cheriton Ridge with views that shout out 'Exmoor'. We find this a wonderful sight on any day. In contrast to our mood, today is gloriously bright, full of promise and beckoning us to get on with things. Behind us, though, is a rough pathway that is set down with small banks either side. We turn about as this is the track we

will follow until we feel it's time to walk back. Bordered by sedge and purple-pink heather showing its thin, gnarly stems, the track meanders along giving far-reaching views to Lorna Doone country. The climbs and combes give the landscape that layered effect that so many walkers, visitors and photographers bear witness to. For us, these are the colours of the moor. Whether they be on open moorland, in wooded valleys or coastal bound, the tonal greens, russets and browns talk to us about the place where we live. As we look towards the horizon, biscuit-coloured grasses meet the ever-changing sky of Exmoor.

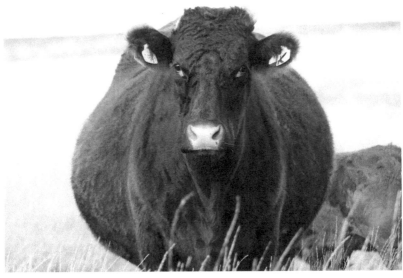

A few clouds scud across the blue expanse as we wander along. Up a way ahead, a herd of brown and black cattle graze. Some are heavily laden in calf; others already have their little ones. Their inquisitive pink noses point in

our direction as they weigh us up and decide we are no threat to them, and they settle back to their peaceful grazing in the warm autumn sunshine as we pass by.

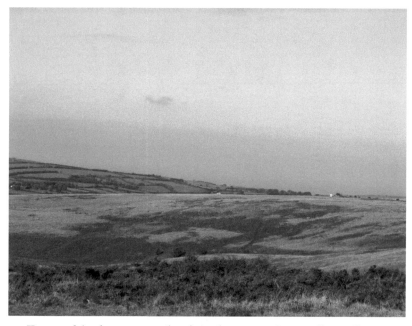

Dotted in between the heather are tiny yellow flowers. They shine out from the darkness of the heather as if they are their very own rays of sunlight, and the sight of them lifts the heart. With four petals apiece and jagged leaves, I believe them to be tormentil. In my own garden I try not to mix yellows and pinks together as, for some reason, it grates on me and makes me feel nauseous. However, out here in the open expanse that is the moor, it sits quite well with me – and who am I to argue with nature? Why the two colours together upset me, I'll never understand. The interior of the cottage blends with what's outside the

window and we welcome the greens, browns and purples of the moor with a more muted palette. Coupled with the glow of the woodburner, mirroring the stunning sunsets of the moor, it's warming and comforting, and it's home.

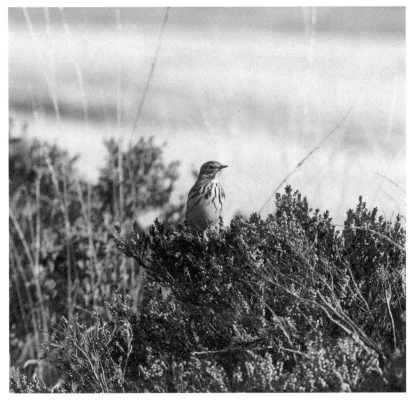

With the sound of silence accompanying us on our wander, the call of a meadow pipit draws our attention to the heather in front of us. As a shortened, watered-down version of the skylark, the meadow pipit is worth a listen as it sits quietly atop the shrubby growth. And then it's gone, flitting about the moor, low, darting and juddering as it seeks its next stopping place. We've seen these little

birds scrap with the much larger cuckoo before now. Wings outstretched and feathers flying, they give as good as they get; it's quite a spectacle to behold.

We are always alert to the possibility of an adder encounter when on the moor. This particular track is sandy, littered with stones and tufts of grass; clumps of heather drape over the bank, meeting the pathway intermingled with grasses. In short, it's perfect adder territory – so I have to be doubly vigilant. As a tomboy growing up, with four brothers, I'm okay with snakes: my husband not so much. I used to carry two grass snakes around with me as a child, tucked down in my deep pockets. They were quite happy to stay in the dark recesses and were constant companions. I would produce them every now and again to show/scare the local Co-op cashiers, much to my mum's embarrassment. Adders would blend seamlessly with the ground that we tread today so, being fully aware of the dangers they can bring, I'm on constant guard, much to my husband's relief. He's not an adder fan on any day that has a 'y' in it, let alone today.

Looking out and over towards Doone country, as far as the eye can see, it's as if a large and lengthy crater is cutting through the land. Shrouded in trees, it snakes through the landscape, taking your eye with it, and it is stunning. Even today, with our sad thoughts swirling around our heads, we can appreciate the beauty. The diversity of Exmoor has something for everyone. The utter peace that is to be found on the moor is priceless

and we don't mind how many times we reiterate that fact. There are more than enough sighs to be heard in our everyday lives and we appreciate every minute that we spend outside. To be able to stand with your feet planted very firmly on the ground, to have the breeze lift your hair, feel the warmth of the sun on your face and to hear the sound of water trickling nearby, or even in the imaginations of your head, is to be at peace with yourself and others. If there was a tree nearby, then I'd be sitting with my back to it as extra insurance to the grounding in my life. Sadly, there are no trees nearby in this wild part of the moor, so I accept what I've been given from the elements today.

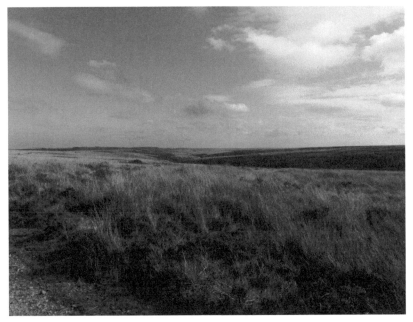

Perched together on an acceptable small boulder, neither of us needs words. We simply sit awhile, faces to

the sun, drinking in the sound of grasses swishing gently in the light breeze and the call of the buzzard. Instinctively, I feel we've wandered as far as we can go today, both physically and mentally. I hand my husband a pear drop and, in our own time, as is usually the case, we begin to retrace our steps and head for home. The cattle have moved over the ground and they don't lift their heads this time. The RAV4 has long gone and with it the *Take a Break* magazine. There are no other cars to be seen and the afternoon will be blending into early evening and dusk in the blink of an eye.

It's on days like these we fully understand how much the cottage means as a home. It is peace personified within its walls. They wrap us and comfort us, bringing calm and contentment, which is what my husband needs right now. Having been and quietly wandered, it's time for words; they will come and I will listen, as the old walls of the cottage will listen too. In all its history, I'm absolutely sure it's dealt with life and with the passing of loved ones. I am certain it is an expert on healing those that ask.

We are not far from home so the drive will be short. Which way should we go? It really doesn't matter in the big scheme of things. Whichever way we choose, the end destination is the same: home, the cottage, our safe haven. It's where we need to be and we couldn't ask for more at this moment in time. Home is calling and home is where we will go.

Woodland Wander

Today is baking day. I've not got there yet but no matter. My friend of fifty-six years video-called this morning, and spending time with my friends is far more important than producing a butternut squash and lemon cake. When we get together, we are sixteen again and we laugh like drains. What was it that William Makepeace Thackeray said? "A good laugh is sunshine in the house." It certainly feels like that for us both. But I'm afraid time goes out the window and now lunchtime is upon us, the morning gone.

Lunch dealt with, I decide to go walkabout and head for Burridge Woods. The day is a good mixture of sunshine and quick over-and-done-with showers. Popping some Polo mints and a Fudge bar into my pocket, I'm out the door and away over the fields.

As it's damp underfoot, and crossing longish grass, I could opt for my wellies but they're not ideal walking footwear. Mine are like carpet slippers. I've had them years, as I did my last pair, which are now acting as flower containers, with thyme and marjoram spilling over the tops. They've found their place next to a pink rambling rose in the side garden. I can look out the back door of

the cottage, see my old boots and reminisce about all the good times we've had together. However, the combination of weather and terrain today calls for my walking boots and Sealskinz socks. There's a need to be comfortable and safe.

My route follows the River Barle for some way and takes me up and over and round and across some of the most beautiful woodland I've ever walked. With birdsong right along the path, pheasants and squirrels surprising me when I least expect it, and the sound of the river rushing on by and waiting for no-one, it's a walk worth doing. It's not taxing, being only around four miles, but in places it can sometimes be rough underfoot, with uneven pathways and squelching mud. It's handy being able to

drop down through the woods, and I can come out on the pathway that follows the winding River Barle along for half the walk.

I've climbed four gates (two wooden and two metal), all of which I've stood and gazed from many times. Each gives a different view and each is special. The last is a small, chunky gate, set down at the bottom of a fairly steep rise that takes me from pasture to woodland. At the bottom of this rise is a badgers' sett, very cleverly hidden with an overhang of lush, green moss. Surrounding this,

a myriad of rabbit holes are peppered about the slope; you have to tread carefully so as not to catch your foot in one and, thereby, take a tumble. Believe me, I've landed on my face more than once.

Woodland floors fascinate me. I've walked these tracks in all seasons and watched the changes happen over the months. Some things, however, don't change. There will always be damp twigs and branches underfoot and a good deal of moss but, come spring and summer, the wild woodland flowers pushing through are simply beautiful. With very little sunlight squeezing through the branches, and against all the odds, the small flowers of the wood sorrel begin to appear, not only on the woodland floor, but on the bark of fallen trees and stumps, left over from the storms. Their heart-shaped leaves, varying in shades of green, are a delight. In May, a time I look forward to every year, wild bluebells produce a carpet of heady scent to accompany me as I pass through. Today the fallen leaves are soggy, wet and clumped together. As I tread them into the ground with each step, I wonder if I'm helping turn them into the vital leaf mould for next year's flora.

The smell of the woodland that I kick up as I walk is reminiscent of my childhood days, of time spent with my brothers out and about and absorbing everything they threw at me. How grateful am I to have been taken out with them from an early age, to be taught something different from each of them. The eldest was a left-handed basket weaver, who was given an apprenticeship on leaving school. He would think nothing of weaving me a living willow chair out of young withies, as we stood by the river and fished. When we'd packed up for the day, he

would undo his patient work, carefully unweaving the thin, bendy twigs, leaving all as he found it.

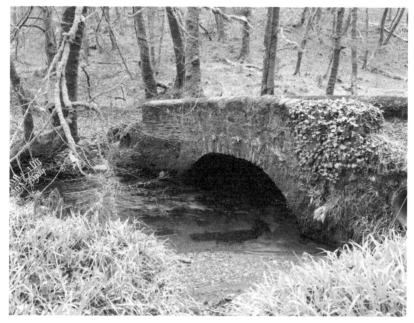

Using the trees to help me reach the pathway, I scramble and slide down the incline. Clinging to the trees, I notice the bark is as damp as my hair, which has given up the ghost in the dampish atmosphere of the woods. The rush of the river calls me towards it. Although parts of this woodland all look very similar and it would be easy to become disoriented, I know I'll never get lost in this vast space, as long as the river tumbles along and I can hear it. On flat ground now, I cross a small but powerful rivulet of water cascading down through the woods. Sometimes it's deeper than others; I'm glad of my boots today. It's like listening to music along this stretch as the

rivulet tinkles in its journey down to the main river, which in turn gives great booms and glugs as it rushes on by. How I love this river.

Always on the lookout for the happy, bobbing dipper, pretty grey wagtails and the vibrant kingfisher – a flash of blue and orange against the white, frothy tops of the river – I gather pace and step out confidently. With the river to my right and tall woodland to my left, it's open and it's light and I can get on, covering ground quickly. There are notices dotted about, informing the passer-by of the cutting down of the diseased ash trees. Always a sad event to witness, the destruction of a mature tree, but a necessary evil and one we have to swallow. The debris left over makes a great habitat for the ever-growing creatures in the wood, so every cloud and all that, I suppose.

The pathway climbs up steeply here. It's crumbly with shale and loose stones underfoot and I know that at the top is a welcome seat for weary walkers, or those who simply wish to take in the view of the surrounding hills. I choose not to take a seat on the simple wooden bench but opt for a beautifully smooth, round post, placed exactly where I want it to be. It's where we always perch when we wander this way, and it's here that I'll nibble on my Fudge and enjoy the view. Up here you can listen to the river, which is on a bend far down below, or there's always a chance of a red deer sighting across the way. On the breeze I hear a magpie's chatter, down in amongst the trees. Even with the woodland canopy starting to thin out with the autumn chill, I cannot spot the caller. No

worries; there's always next time. The colours of autumn can be seen in all their glory from such a height and it makes me sigh with contentment. That's not anything new, though. I seem to do it regularly on my wanders.

If I'm going to go a purler then it's on this next part of the path. This is the downhill trek on a loose shale-type track, which is steep. I can never tackle this without my trusty stick: a wooden, smoothish lump of hazel that keeps me company on many a walk.[1] It's longer than usual and has a fork in the top where my thumb rests nicely; it's as if it was made just for me. It's my chosen stick when on such a walk, and has been a friend for thirty years or more. I used to collect wooden walking sticks in my earlier years and have quite a few, loving the feeling of wood beneath my fingers. Always a comfort when I'm walking. In this broadleaf woodland I walk beside and under oak, beech and some healthy ash trees. I think about how the oak from this wood has gone on to make signs and gates for our National Park. It's a great feeling to know the woodland has useful resources.

The floor is carpeted with bracken and ferns, turning shades of brown, orange and then yellow as the days tramp on. Holly and hazel trees, smaller in stature than the oak and beech, but nevertheless important, build the next layer of undergrowth. Amongst these trees, some sporting lichens on their branches and fungi at their base,

[1] See photograph on P.4

the robin sits, its song blending with the call of the blue tits and great tits as they flit about the huge fallen tree trunks. A rush in the undergrowth cannot hide the fact that the squirrels are out and about, no doubt collecting and harvesting food for the coming months. They scramble and twist up the tree trunks, blending seamlessly into the bark as they freeze, pretending not to be there. But it's too late and I have my eye on them.

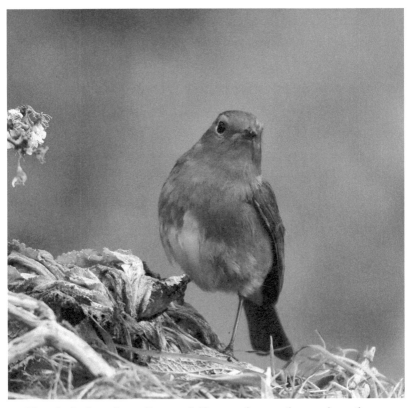

I've left the river for a while, as the pathway bends away from its course. Following an ancient beech hedgerow, on the other side of which are fields, I'm now reaching an

incline, which gives more views over the surrounding valley. All along this stretch, in the summer months, the smell of wild garlic fills the air, its flower brightening up the darkest corner of the wood. It heralds the end of my pathway and I've come as far as I want to go. I'll leave the next section for another day but should now turn back to pick up the lane for home. My mind wanders as I climb the winding hill, still through woodland, but on more even ground. I pop in a Polo mint and think about our trek through the woods last summer, with our grandson. He played and paddled in the river, we measured the length of fallen trees in footsteps, collected feathers, watched beautiful beetles, and laughed at how the cleavers, or goose grass, stuck to our clothes. There was a picnic to be had that day, sat on a tree trunk in the heart of the woodland. It was a magical day full of memories.

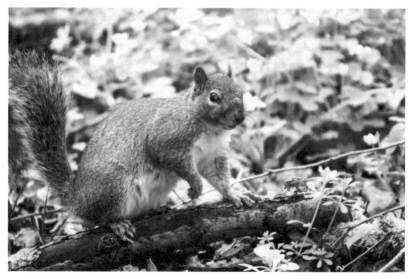

Thoughts turn to what we're having for dinner this evening. Something easy, I feel, to match the relaxing day I've had. The cottage is calling so it's best foot forward as onwards and upwards I climb. A simple day – but more often than not, they're the best days ever.

Mixing 'Business' With Pleasure

On our notice board there's a 'to do' list. It's our reminder that there are things to be done before we go off gallivanting about the moor. Sometimes we pass it by with our eyes closed, ignoring its presence; at other times it shouts out our names, asking to be seen. Today is one of those days. We mostly work together, whatever we do, but never before devouring a hearty breakfast. Today we've had a full English with eggs from down the lane and bacon and black pudding from the local butcher. I've already put a lump of beef to slow cook on the woodburner and my husband has sorted the logs for the day, so we can sit, relaxed with our coffees, watching the birds at the bird table enjoying their breakfast too.

We've noticed that the blackcaps have been regular visitors this summer and they're still with us as the colder months begin. If they do decide to migrate, then we will miss their warbling song, which is rich and varied. Around the bird table there are shrubs and trees plump with berries. Perhaps that's why these pretty birds have stayed hereabouts so long.

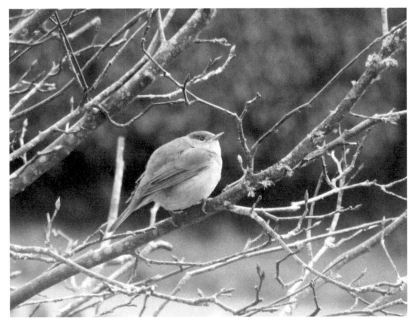

Just outside the back door is a proper Exmoor wall and bank. It's been there for many years but atop this bank are various shrubs and trees, not the beech hedging that you'll usually find associated with such a bank. They're in need of a thin and a trim so that's the first job of the day. It's quite chilly outside but the sun is shining, albeit weakly, so good physical work will keep us warm – and we're used to it. We've lilac, honeysuckle and a white shrub (whose name I can't recall) to trim down, so, with loppers in hand, we begin. I love the bank and the log store that sits beneath it, which we built ourselves. The simple wooden store hasn't been there as long as the walled bank, but they blend perfectly together. I always become anxious where there's cutting back involved – not for the shrubs we're cutting but for the smaller plants that may get trampled

underfoot. I'm extremely lucky to have this bank so close to the house. It gives me the greatest of pleasure all year round and bursts with snowdrops, primroses, dog's-tooth violets, and celandine in the early months. Interspersed with these I've added lungwort, forget-me-not, St John's wort and herb Robert, the latter being a pretty pink flower on attractive darker pinky-red stems, but which smells dreadful if you brush up against it when weeding. Campion, lady's mantle and ferns will follow on.

Every single day I am grateful for our bank. To say that the birds and wildlife love it is an understatement. A myriad of birds come and feed from what's on offer but my favourite is the little cheeky chaffinch. Its song rings out throughout the passing hours and can still be heard until early evening. I can sit in the evening, on my loyal wooden bench, waiting for my husband to return home safely from work, and the chaffinch keeps me company. A little bird seed scattered about never fails to draw their attention and their song will always fill me with cheer. In the peacefulness of our garden, it is this pretty bird's voice that I would miss should it ever decide to go elsewhere.

From our working area we can see right across the moorland. The greenness of greens is no longer with us across the valley floor. We now see the vibrant colours of autumn amidst tall-standing fir trees. It all makes for a stunning view as we toil away. We're happy in our work – and who wouldn't be with views such as ours? Half-time says it's our first coffee break and I'll nip into our small but homely kitchen to prepare. Thinking it would be too greedy to eat cake so soon after breakfast, I opt for a homemade spiced oat cookie instead, and deliver it to our waiting bench.

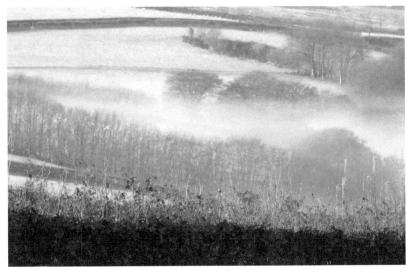

We have all sorts of people pass by the gate – walkers, riders, dog walkers, cyclists – and all will hold a hand up to wave or even stop to pass the time of day. It's refreshing to chat to new people and none can pass without glancing in. Perhaps there's talk of my cutlery tree

in the garden; who knows? Over the years I've collected pieces of cutlery from boot sales and not knowing what to do with my growing collection, I took myself off into the garden, wired them up and decorated a tree with them, in view of the gate. They've hung there for a few years now, swaying in the breeze, twisting if the wind catches them. It's different and it's quite pretty and I reap so much joy from them as each piece has a story to tell. They make me smile as I pass by to collect a basket of logs.

Not the original cutlery tree, but a new start to the old tradition.

Sitting there on our bench we espy our resident pheasant coming down the path. He's been about for ages and ages and is quite distinctive with his crossed and bent beak. I don't usually feed him but he gathers scattered

seed from the bird tables and feeders and certainly has his fill, one way or another. However, I do allow our grandson to throw him a few seeds out of his bedroom window here. The small bedroom window looks over the back of the cottage, and has a low roof beneath it from the kitchen extension. The pheasant will take to the sloping roof if he spots the window opening: that's his cue. It doesn't matter if I'm cleaning the windows or airing the room; if that window opens, he will be there, shouting at me with his rattling call. A small snack and he's gone again, until the next time. We'd miss him if he didn't come to call.

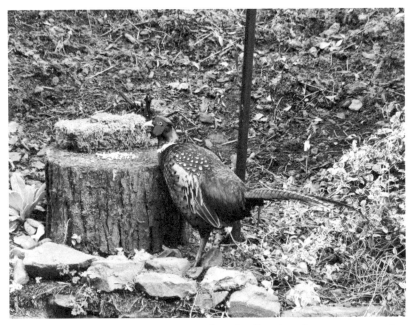

Coffee break over and the holly is the next to be tackled; we've left it until last. Its prickly leaves are painful to handle without a pair of stout gloves on. I refuse to cut

holly back or remove it from the garden under any circumstances, and it never comes into the cottage until Christmas Eve. I did read somewhere that holly was a frequent hedgerow tree because it was considered unlucky to cut back by some farmers, so it flourished in the hedges. By the same token, we never burn holly on the fire and it is always returned to the earth after Christmas.

I remember, as a child, my parents knowing a travelling family whom they would visit frequently on the marshes. I can recall watching them, at Christmas, weaving and making holly wreaths for sale in the local shops, under a crude canopy, barely sheltered from the elements. The wreaths were beautifully made with huge red bows hanging as decoration. They were were made by ungloved hands, which were browned and like leather, and they worked quickly. You'd have to go a long way to find a better wreath. We were always given one as a present, which made my mum so happy. She would take them a festive cake tin with a Victoria sponge, rock cakes and mince pies hidden inside for their kindness. That was my mum all over and I'm proud to say that I'm very much like her.

An abundance of holly berries is believed to herald a bad winter and I've never had cause to doubt this piece of folklore. In my eyes, nature will provide enough food for birds over the colder months, when the frost and snow prevail. Everything in nature is there for a reason and very little is there for the sake of it; our beautiful,

giving hedgerows are there to provide for both animals and us alike. So, holly stays and is simply tied in and tidied up. As we transport our garden waste to its resting place, I sift out the twigs I'll need to decorate the cottage at Christmas. I also keep enough to adorn the front gate, as I always do. Then the larger, longer branches and twigs are weeded out too, as I'll always have an extra twiggy Christmas tree in the dining room. I decorate this with home made decorations that I've made over the years, in reds, greens and golds. It's always a talking point and earns its place well. The remainder we pile up in the corner of the garden, amongst the undergrowth of brambles and bracken, for the smaller inhabitants of our world. So, very little is eventually taken to the garden heap; it's a job well done.

Having worked off our breakfast, we regroup in the cottage kitchen, where it's warm and homely. Eventually, the mouth-watering smell of the cooking beef drives us out again as it finds a home up our chilly noses. Time to go a-wandering. So, as my husband stokes the woodburner, I throw together and pack up a quick lunch with a flask of tea and we are out the door once again. Our feet take us up and across the lane where, crossing two fields, we climb the oldest wooden gate you ever did see. It's so old it fails to open any more and is more a gap filler than a gate. Wound round and round with orange and blue baler twine, it has its own stories to tell. We follow a line of beech trees down to a well-known bank, where rabbits scamper back to their burrows as they feel

our footsteps on the ground, the white under their tails a sure sign that they've heard us.

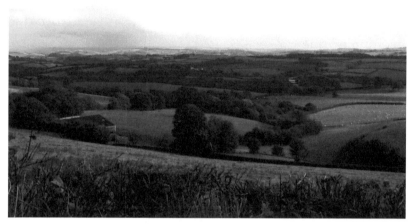

Here, amongst the grasses and small rocks, we take our lunch. It's a go-to spot for us and we are fortunate enough to have permission to roam these stunningly beautiful fields. The landowner told us one afternoon that they were merely custodians of the land, looking after and caring for it until it passes over once again. It's a safe haven for the red deer that wander here and we've witnessed some magnificent sights over the years.

An evening walk during the early summer months found us coming across several young stags, still in velvet, all lined up together, two fields over. They grazed on the grassy slopes, safe in the knowledge that they had tree

cover to escape to should it become necessary. We've also had a sparrowhawk fly around us as we've sat quietly amongst the thistles and scrubby grass. It used an old, gnarly, twisted thorn tree as its perch, flying backwards and forwards along the hedgerow. It's the first time we'd seen one up close and we were loathe to move, but the evening was drawing in and we sadly had to pick ourselves up and leave him to it. So many memories made from one evening wander.

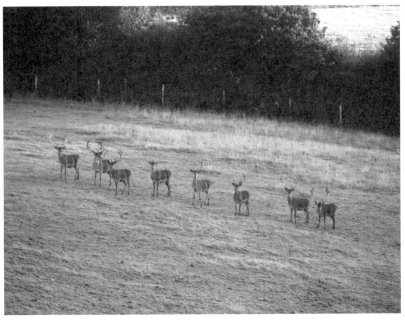

Looking out over the surrounding patchwork of fields, still looking lush and green, but which are now dotted with the colours of autumn, we know and understand how lucky we are. We, too, look after this land we find ourselves part of, and which is part of us. Wherever we can we will pass our knowledge on to those who want to

listen – but most importantly to our grandson, whose knowledge grows with every visit. If we can keep even a tiny iota of interest going with him, then it's a job well done.

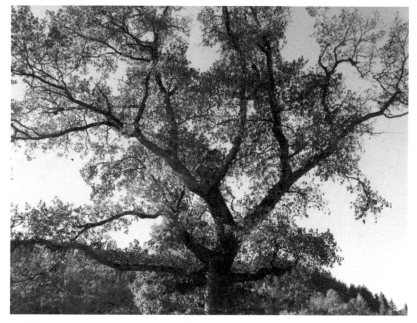

Lunch time is over and we must retrace our steps home once more. There are logs to be split and starters and lighters to be tied, now they've dried out a little. Our friend the wind has seen to helping us with the drying process; thank goodness for nature. We'll look forward to the warmer months when we will see the spiders sitting in the centre of their webs, heralding hot weather for the day to come, but until then we will revel in seeing the dew-laden webs in the hedgerow, sparkling in the autumn sun after a misty start. Every season has its high spots,

whatever the weather, and it's those that we take with us as our memories, as the seasons change.

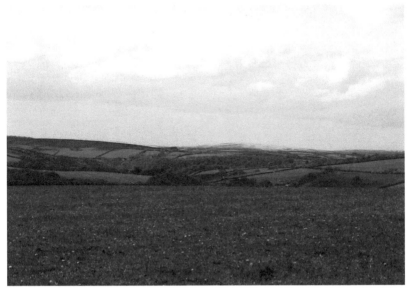

As we amble back along the hedgerow, I can see the fluffy, silken seed heads of travellers' joy – old man's beard – catching the afternoon sunlight. It's quite rapacious in its growth and habit as it clambers and clings along the hedgerow. I'd love it in the garden, as I think it's from the clematis family, but it would make short work of climbing along our hedgerow. It's better left out here to be admired and appreciated. Very pretty though.

The gate is in sight. We're a hop, skip and jump from home. Home, where the smell of slow-cooking beef will assault us as soon as we step over the threshold. It's a good job we still have a list of jobs to do outside: a list that is growing shorter by the day and, perhaps, not shouting out for attention anymore. At least we will work

up an appetite again in readiness for our dinner this evening. And anyway, it's no hardship to be outdoors, working in such a beautiful environment with views to die for. There are worse things in life and we know how fortunate we are to live in such a beautiful place as Exmoor. Very fortunate indeed.

A Foggy Autumn Day

In the warm, distorted glow of the porch light, I can see that there's a bit of a pea-souper wrapping itself around the cottage this morning. It feels like there is an extra layer of insulation trying to cling to the outside walls, the fog is so thick. All is silent. I drop the curtain back into place and head downstairs for my morning cup of lemon-and-ginger tea. It's 6am and I'm trying to decide if I should return to bed with my tea and toast, and prop myself up amongst the still-warm duvet with my book, or stay up and make a start on the day. It's days like these when the quietness of the cottage, and all it encompasses, urges me forward to make the most of the hours I'm given. So, deciding on the latter, I decide to bite the bullet and light the woodburner.

My kindling, starters and lighters for getting the fire going are all kept ready and waiting in the boot room but, as we didn't have a fire yesterday, it's ready laid and waiting for me. As the flames lick around the larger sticks I add a couple of logs and shut it down a little. The room comes alive with the orange glow of the fire and there is a welcome, a comfort and a friendship there, and I no longer feel I am the only one in the cottage. I remain

kneeling in front of the hearth, as my mum would have done, watching as dancing flames take hold, and I am transported back to my childhood once again. Fire now alight and needing my cup of tea and toast, I return down the hallway to the kitchen to sort myself out.

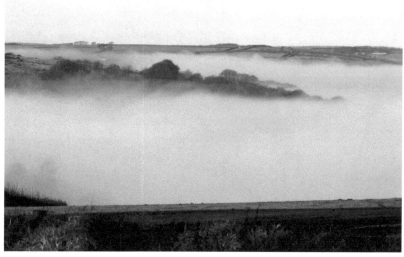

The warmth of a fire draws you in and I always feel compelled to sit with it, bathed in the glow and watching the fan spin around so fast that I can imagine the woodburner taking off like a helicopter and disappearing out through the window. It's amazing how much warmth the fan can generate off the heat of the fire. With my buttered toast I return to the hearth and get comfortable, tucking my legs up underneath me; I keep the fire company. I tell myself that I'm sitting here because I need

to keep an eye on it but what I'm really doing is taking fifteen minutes for myself, connecting with our home. The protective walls of this old cottage envelop me and I chat to them about the day that lies ahead of me, knowing that they will listen to anything I have to say and not judge me.

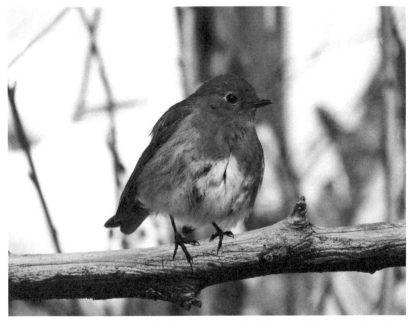

Time to move and don some clothes and, opening the white slatted blind, a quick glance outside reveals the fog is still swirling about. It can lift as quickly as it lies on the moor, the weather ever-changing. But at least it's becoming lighter now and another Exmoor day is about to begin. I have a feeling that my robin won't be sitting on the gate this morning, as he usually is when I'm drying my hair. But, I also have a feeling that it's not worth me sorting my hair out on a day like today and that I'll simply hide it under a hat instead.

First things first and I have to prepare my casserole for dinner. I look through my playlists, and choose one that is primarily The Czars, John Grant and Richard Hawley: quiet and reflective, like the weather outside my kitchen window. It is not quite so quiet inside, with me bashing about, chopping up vegetables and throwing them into a large pan, together with some browned chicken pieces. My husband calls the pan my 'cauldron' purely because of its size and because it sits atop the woodburner, just under simmering point, all day long. I take no notice of him as we both know that what my cauldron produces at dinner time is both hearty and mouth-watering and he will never refuse a second helping.

With the log basket replenished, the casserole on and the woodburner stoked and settled, I can get on with my daily task. However, the task was to light the garden incinerator and start to burn all the beech leaves that I raked up yesterday. Whether they'll be crispy and crunchy enough to burn this morning, after the foggy start, is another matter; it just might have put a dampener on things in more ways than one. Only time will tell. So, with a hot coffee in my travel mug, I venture outside.

The fog has lifted enough to be able to see what I'm up against and it's not as bad as I thought it might be. Yesterday I piled up a good few of the leaves into my leaf-mould mound; it's a never ending job in the autumn and they just keep coming. There's more than enough to go around and if I collected every single leaf that fell from

the tall beech trees around the cottage, then I'd have a heap the size of Mount Everest: hence having to burn some down. And so it begins.

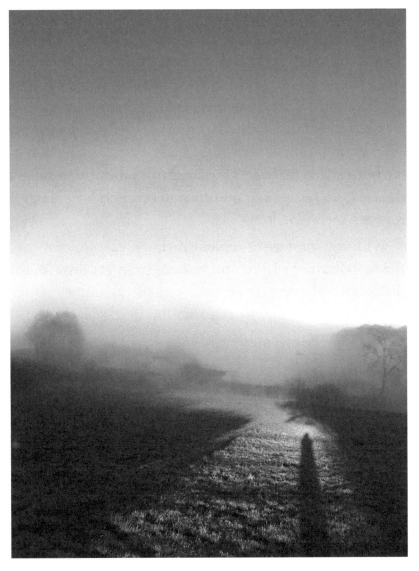

The velvety song of the robin rings out from the hedgerow as I begin the second fire of the day. I can't see where he's to yet but I guess he'll show his face once I start to move the leaves about. He'll be grubbing about next to me before the next five minutes are out. Always the chancer for a worm or two, he'll trust me to let him be, while he sifts through the debris I'll no doubt leave behind me as I work.

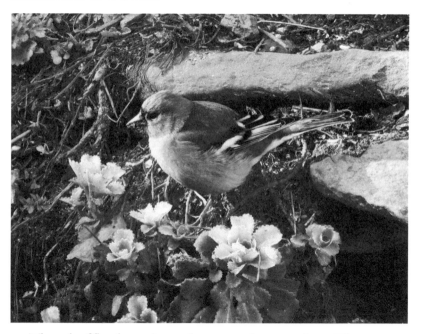

The chaffinches sing whatever the weather. They are a constant in the garden and I welcome their chattering call. I'm in two minds about the jackdaws, though. I enjoy their cheeky nature, that tilt of their grey-scarfed heads, as they decide on their next move. It's as if they're asking me a question and waiting patiently for my answer. Their

chuck-chuck call and the cottage are as married together as bread and cheese but, boy, are they noisy. It's like having fairy elephants tramping about on the roof around the chimney pots – and that call echoes down the chimney when the woodburner isn't lit. Together with the wood pigeons *vroo-coo*ing, it's quite orchestral in the lounge at times. I shouldn't complain, though, as I love them all really.

So, my plan is to move the topmost, dampish, leaves to the small Everest heap and burn off the drier ones. The powdery grey ash left over after the job is done will go onto my flower beds to join the ash from the woodburner. Nothing is wasted - it's how I like it to be. First, I must check that Hedgy the hedgehog (or any of his family) isn't tucked up under the pile of leaves. The main body has only been there one night, but a lot can happen during the night hours with wildlife. I'll have a poke about in my once-burgeoning pile and then check as I work.

The top of the garden is where I'm working today. There's yet another beech hedgerow here and it's where the red deer come through into the small field that borders our lawn. When we first found deer slots and droppings in the field, we could not work out how they were

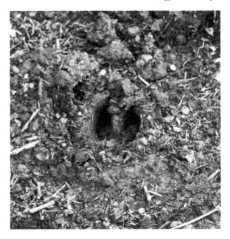

gaining access. The old hedgerow is on top of an ancient grassy bank and, therefore, much taller than a normal hedge. There are also no gates in this section and no evident gaps in the hedge. It was only when we set the trail cam up that we discovered their point of entry. These beautiful creatures were jumping up the bank on the other side, walking several metres along an extremely narrow corridor, which had somehow been made between and inside the beech hedgerow, and then jumping over and down on our side. Amazing how small a gap these animals can get through. We love having them visit and, every day, I go and wander the field to see what treasures I can find, that the deer have left behind. They are metres from our kitchen window and I love knowing that they're out there in the night-time hours, when we're asleep.

In the spring the field is awash with lady's smock or the cuckoo flower, as I know it. As it emerges and comes into flower it's a reminder to listen for the sound of the first cuckoo, from across the moorland. The delicate little flowers keep the bees happy, and they also have a peppery taste to them. I've been known to throw them into a salad on many an occasion.

During the summer months we have a small flock of sheep and their lambs visit, to keep the grass down and to fatten themselves up. It's a small price to pay, ensuring they have enough water and feed, in exchange for their company during these months. To sit or work in the garden and hear them munching away on the grass, just

the other side of the fence, is a sound I'll never tire of. When the heat of the sun shines down on this small patch of land, they will all go and sit under the shade of the welcoming beech trees. There is nothing quite as quintessentially English as the sight of them all lazily languishing in the shade of the leafy branches. It's a busy old field that changes with the seasons in more ways than one.

I'm well on the way to completing my task today and the leaves are burning nicely. The smouldering contents of the incinerator send a curling ribbon of smoke out through the small chimney and up into the sky. It's a tell-tale sign that a garden is being cleared of leaves and the wispy smoke melds with the remainder of the fog on its journey. Smoke from the woodburner mingles with that from the leaves and I'm happy in my work, even though the sun

hasn't broken through the lingering fog patches. It's a typical autumn day and one where it's good to be outside, toiling away with a warm fire to keep the chill at bay.

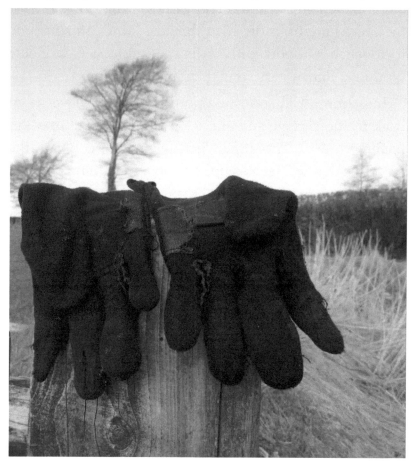

I always wear an old pair of black riding gloves, even though I haven't ridden for years now. They have been heavily repaired over the seven years I've had them and have lost most of their plastic patches from the thumbs and palms. Like my trusty Dublin River boots, they are a

constant in my life as they are extremely comfortable. They garden with me, muck out the stables with me and wander the fields and Exmoor with me. I feel naked and incomplete without them and wonder what I'll do when they really are no more than threads. How can someone form such a bond with a pair of gloves, I wonder? Methinks I am a very strange individual at times.

Lunchtime will soon be upon me and I'll have to go back to the cottage and check on the other fire that I'm feeding today. The other fire, which is cooking the casserole that will feed us this evening. I might make some sweet potato mash later to go with it, and use some of our home-grown runner beans as the green bit. There are not enough hours in the day so I won't have time for a wander this afternoon but I'm thankful that I'm outdoors with my own thoughts and the sounds of nature to keep me company. It's a simple life and exactly how I like it, and it will be a good job done for another year. I once read somewhere that 'you create the weather in your own world, if only in your head' and I feel like I've done just that today. What started off as a foggy, murky morning has turned into a sunshine-filled few hours for me – all in my head of course, but what's the use of a vivid imagination, if you can't use it?

A Bright November Stroll

How can be it be the middle of November, with the weather we have today? It's Sunday, and instead of being damp, misty and chilly it's absolutely glorious outside. This morning has seen walkers passing by the front gate along the narrow lane, sticks of various colours in hand, backpacks on their backs and with a spring in their step.

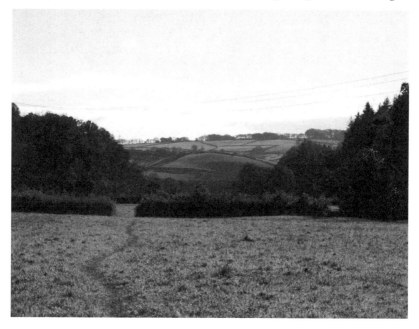

We have a pretty good idea where they're headed, so we decide to make tracks in the opposite direction. Donning my green Bear Grylls fleece, which I purchased from a charity shop several years ago, I tuck my Polo mints, Fudge bar and tissues in the top, zipped pocket. It's an ideal size for all my paraphernalia and I need nothing else, apart from my own stick. I've selected my long, forked specimen today, as is usual, because I trust it not to let me down.

Needing to drive a little to our destination, I stand guard on the lane and see my husband out onto the road. We're on a bit of a bend and it's a habit we formed when we first moved here – probably quite unnecessary but a habit nonetheless. The lane is banked and topped with beech on either side. During the warmer months it's underlaid with bluebells, frothy cow parsley that sways in the gentle breeze, and pretty red campion. At the moment it's sporting bracken and ferns, in yellows and browns,

waiting for the winter to claim them in the weeks ahead. Whatever picture the lane throws up, I accept and bathe in its beauty; it is a forever-changing living photograph and a part of me. Is it childlike to want to swish and kick up curling, crunchy, crispy autumn leaves on a walk? I don't even have to think about the answer as it's an easy one for me, and I'll do just that at every given opportunity. I've also been known, when out with our grandson, to pick up armfuls and toss them into the air, letting them fall to the ground, floating down onto our heads in the process. It never fails to start the giggles between us and we will spin with our arms outstretched in pure joy. Today, however, I don't think there will be much scrunching going on as, despite the warmth of the day, the autumnal leaves underfoot are damp, soggy and very stuck together.

As we make our way down a narrow footpath alongside a small river, a military helicopter flies low overhead, interrupting not only the peaceful silence of our environment but also the birds. They erupt from the fields in a flurry of movement, headed for the nearest trees. I guess they'll settle again soon enough. Along this stretch the hips and haws are glowing and plump, hanging in the trees like tiny Christmas baubles, but holly berries are few and far between. The few that I see sit at the very top of the holly trees and there are some trees that are completely bare of berries. A male blackbird flies down from the hedgerow, landing on the path just ahead of us; a warning call goes up as another male joins him. A bit of

a chase ensues and they're gone again, into the beech and hazel trees to fight out their differences.

We have three blackbirds that visit the garden at any given time. Sometimes they're all together and sometimes individually. They seem to tolerate each other fairly well and take their turn at the bird table in their own agreed pecking order. Come spring, the female of the group has her pick of partners, and that's when the scraps begin: chests out, tails straight, low dives, and warning calls aplenty. But they sort themselves out eventually and peace is restored. I love to watch their antics.

Today's walk, being quite flat and level, with just the browning tussocks of grass to contend with, is easy going. The grass is dewy and damp but not tall enough to drip over our boots as we wander alongside the fast-flowing river. Overhanging, semi-naked trees dip their slim branches into the white-topped, rushing River Barle. The incessant roar as it tumbles along reminds us just how powerful it is. It swallows the fallen leaves and twigs, taking them with it on its journey towards its convergence with the River Exe, some way down the line from where we are. In the distance before us sheep graze on the hillside; to the left, cattle, burnt umber and conker-brown in colour, roam the land. Woodland borders the field we walk in and we know that its inhabitants include a strong herd of red deer. They're hidden from sight now and rightly so. In the bright sunshine of the morning they would stand out like sore thumbs, glowing warmly and richly against the backdrop of skeleton-like trees. It's a

given that they remain protected and the rich woodland, with its abundance of native trees, affords them that cover and camouflage.

I'll continually look up as I walk. Up at the sky, up through the branches of trees. Their leaf canopy always enthrals me so. I'm drawn by a tree that has a wonderfully decorative covering of ivy, clinging and climbing up its trunk. As I wander over to take a look, there's a rasping, deep-screeching sound as I approach. I know that a squirrel is probably taking umbrage at my proximity to 'his' tree, so I reverse myself and leave him in peace, but not before taking a photo of the ivy-clad tree.

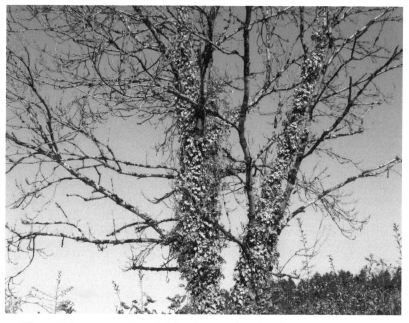

Brambles are plentiful along the hedgerows here, the brown stalks left behind by the now picked blackberries

the only evidence that the shiny black fruits were there at all. I wonder if it was humans or wildlife that stripped them bare, harvesting the berries? I'll go with fifty-fifty: we enjoy picking the purply-black gems as much as do the bullfinches that we see outside the front room window of the cottage

There's a wonderful, huge and old oak tree in our sight, its shape giving it away almost immediately. As we make our way over thistle-rich grass, it grows in stature and we begin to really appreciate its size. Strong branches reach out sidewards and upwards towards the day's blue, cloudless sky. Roots, which anchor it to the ground, reach

just as wide. At the foot of it there are some smooth rock-type boulders and its base resembles that of a mammoth-sized elephant's foot. I wrap my arms around it but they don't even go half way around. Resting my head on the bark of this beautiful, beautiful tree, I listen to the secrets the ancient oak imparts of those that have gone before us. Some find it strange, but I find it extremely calming and it rests my soul. My husband looks on, giving me my moment with the tree, but he, too, takes in its presence. Like a majestic stag presiding over his herd, protective and powerful, this tree holds court over the land. It is magnificent in its beauty and I nod my thanks as I walk away.

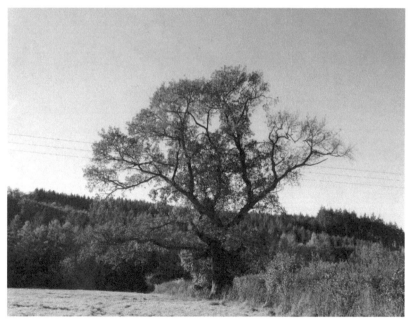

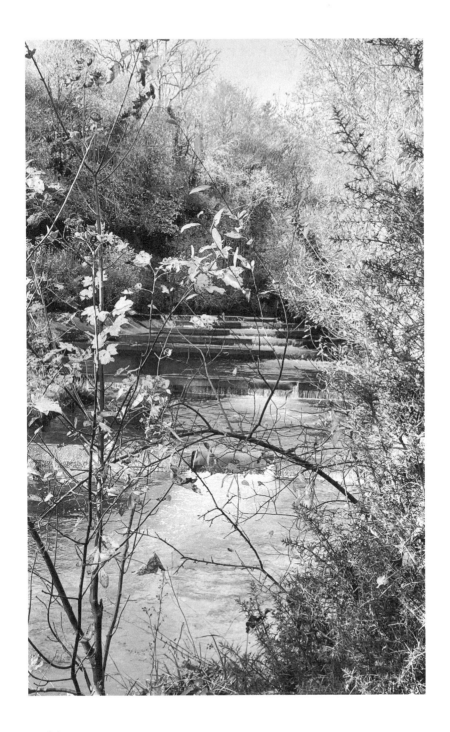

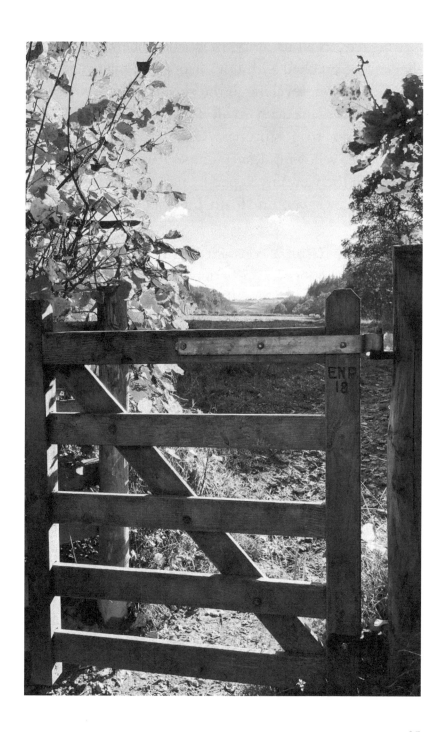

This day, in all its glory, must surely be a bonus, one that's to be grabbed with both hands and made the most of. We walk on, revelling in the sunshine that warms our bodies, and come to a small wooden gate. It's far too tempting not to go through. Greenery cuddles it from either side, yellowing leaves drape around it on spindly twigs, and the view enveloped by nature is too alluring to ignore. So, we venture forth into yet another area of pasture.

The river is still a constant and flows freely again, a mixture of colours in greys, icy blues and browns. Tall trees in all their autumnal finery call us to cross the grassland. As we make the crossing the plaintive mewing call of the buzzard takes our attention. There are two, soaring high, their silhouettes stark against the azure blue of the sky. It's amazing that we can hear their call, down on the ground, from way up where they fly. It's impossible to see their dark wing tips, they're so far up and, if it wasn't for their cat-like mew, we'd probably have missed them. I know that we can see them all over the moor, but it's always a pleasure to observe them.

Up along the river it's calm and peaceful, the water like a millpond, in contrast to what we saw earlier. The Barle is a river of two halves: you'll find this difference in many of its stretches. Here the river is so very clear and the pebbles and stones on the bottom reflect the colours of autumn almost exactly. In the background, we can still hear the rushing of the frothy waters we've since passed, but it's faint. Faint enough for me to stand with my

thoughts, to hand them over to the river's keeping and to let them flow away with the moving waters. It's time to turn for home.

Another wander is set for this afternoon but we have to journey to Barnstaple first, eating lunch on the go. We'll stop on the way home across the moor, slip our feet into our boots and be off again. I cannot begin to describe the feeling of freedom and joy that I feel when I'm out amidst the beauties of our moorland. Its artistry is mind-boggling. The terrain, the colours, woodland, combes and coast, the wildness: there is a beauty in nature wherever you look and I, for one, cannot get enough of it.

A Porch Light

Finding yourself lost on unfamiliar territory is scary. I've been there and done it and I don't think I'll ever forget the sense of sheer isolation at being lost in a Bedfordshire woodland, over thirty-five years ago, with my two children. No mobile phone, no technical gadgets whatsoever, no clue as to where I was. Simply because I took the wrong pathway along our late afternoon stroll. I now ensure that I have as much back-up as I can when I wander but some people, like me way back then, still chance their luck at being able to find their way back whence they came.

Being on the moor, and along a narrow lane, we are used to walkers passing by our wooden gate. We are quite open part-way to the front and it's not unusual to see people leaning over the gate, or craning their heads to see into our front garden. It does make me smile somewhat and, if I'm out gardening or chopping wood, I'll normally give a wave or even go down to chat to them. In the late winter afternoons, when the sky darkens and the weather begins to close in, I'll turn on the outside porch light, which will glow like a beacon, welcoming my husband home from his day's toil. It is the only light that you'll see

for miles and it's been a friend to many. Along the gravel pathway towards the white back door, which is the door we use all the time, there is a sensor light. This will click on when we most need it: especially helpful when we've been out and about and the porch light hasn't been turned on. It also alerts us that somebody is approaching the back door, which we find is a necessity here in the velvety darkness.

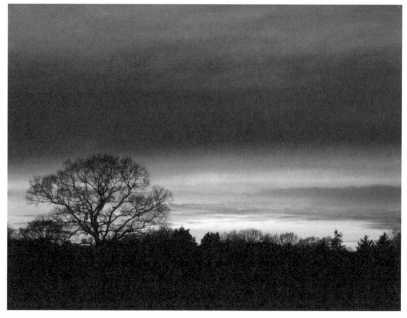

A few years ago, during the autumn months, I was at home alone. It was a murky day outside and, being early evening, the Exmoor mizzlies had set in good and proper. It was an evening where I looked forward to being in front of the fire, curled up with a decent, warming whisky for my husband, or a cup of spiced orange tea for me. Our kitchen is smallish and cosy and suits us well and I was

preparing the table for dinner, expecting my husband any time soon.

Normally, I know roughly where he is and I'll go up our curving stairway to the front bedroom window to watch his progress down the winding lane, his headlights shining the way forward towards home. There's something quite fascinating at being able to watch the glow of a vehicle, in the silence of the night, making its way towards you, even though it's some fields over. Waiting for that same vehicle to make a right turn down the lane, disappear from sight for a few seconds as the road dips down, only to reappear and eventually pull in through the ready-opened gate, never fails to fill me with a feeling of warmth that we are home; we are together and safe for another day.

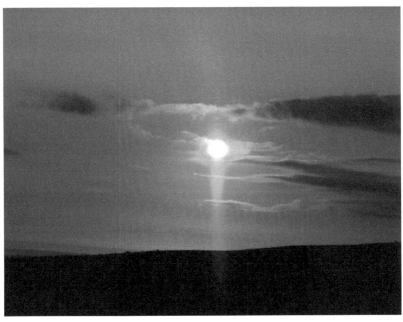

On this particular day, I'd prepared a healing stew, which is one of Fearne Cotton's delicious recipes. Full of vegetables, quinoa, kidney beans and spiced with turmeric, ginger and cinnamon, it is a winter warmer and I'd been cooking it on the woodburner for a couple of hours. I'd been pre-occupied with making a spelt loaf with rosemary and red onion, and was busy rescuing it from the oven. Because of this, I hadn't ventured upstairs to see if any headlights were making their way down the lane but wasn't surprised to hear footsteps on the gravel path or to see the outside sensor light kick in. What was a surprise was to see a rather bedraggled gentleman standing outside and peering through the window of the back door. This was obviously not my husband, whom I was expecting.

Looking damp and apologetic, with his hair stuck to head, his jacket shining and wet, and shoulders hunched against the weather, the man gave a small, friendly wave as I placed the loaf on the hob and made my way across the kitchen to open the door to him. He dipped his head on one side and apologised for disturbing me and, directing my gaze to the front gate and his wife, who was also looking the worse for wear, explained they were extremely lost. He quickly asked if I had a number for a taxi rank that they could ring as they'd been walking for miles, had become lost in the woods and were making their way back to Dulverton, where they were staying. The wife stayed put at the gate, not moving but hunkered down in the collar of her coat. I had to think clearly about what to do next as memories of my escapade through the woodland all those

years ago flooded my mind. But I had to act safely because I was very aware that I was very much on my own.

I made my decision and asked him if they'd like to step inside out of the weather, as there was no hope of calling a taxi any time soon, and that we'd sort something out. Beckoning to his wife, to let her know it was okay to come in, he explained that they'd seen the porch light shining out of the darkness and were so grateful to find it was attached to a house and 'a life form'. I offered them a seat at the table and told them I had to make a quick phone call to my neighbour, during which I explained what was happening – and immediately felt better that somebody knew I had unforeseen callers. Now I could turn my attention to my unexpected and very tired visitors once more.

As with any visitors to the cottage, I offered them a hot drink and, while they took their wet jackets off and I put a kettle on to boil, they told me they'd only set off for a quick wander through the woods from Dulverton and had quickly become disoriented. Apparently, they'd been wandering around for hours, becoming more and more lost and, obviously, further and further away from where they wanted to be. As it began to grow dark, the blackness shrouding them in the woodland, they'd panicked but had come across an uphill pathway, beside running water, which had led them to our lane and our porch light. Admitting that they'd been alarmed at not knowing where they were and having not a clue how to fix it, they explained they felt quite irresponsible. But, you see, I

knew those feelings well and also knew how easy it was to lose your bearings.

With their wet outdoor things hanging over the radiator in our boot room, I gave them a fluffy green towel each to dry themselves off with. Our friendly cottage wrapped its arms around our visitors and, with a steaming hot cup of tea, which they gratefully wrapped their hands around as they slowly sipped, they sat on the barley twist chairs at our kitchen table and relaxed a little as warmth returned. After asking how many miles it was to Dulverton, and deciding it was much too far to walk, they were still insisting that they would call a taxi. I think they were astounded at just how far they had actually walked and how drastically lost they'd become. But with my husband due home any time soon, I said that we'd take them back down into Dulverton as soon as we could. I ushered them into the front room, where the woodburner gave off a warm, homely, orange glow. The two strangers looked absolutely shattered as they sat, so very grateful for shelter out of the damp night air. My cauldron of healing stew, aptly named I thought, was sitting atop the woodburner and there was no reason why I couldn't and wouldn't offer them to join us for something to eat. The smell must have been making their mouths water, as it does most people who come into the cottage when I've a casserole on the go. I'm no cordon bleu cook by any means, but I can produce a good pot of something warming and filling. I'm also a dab hand at whipping up a tasty spelt loaf but, to be honest, I think

they'd have eaten anything I put in front of them that evening, as they hadn't eaten or drunk anything since noon.

So, with no further ado, I asked them if they were hungry and if they'd like a bowl of something hot with us, explaining that it was a simple stew with homemade bread. They looked at me as if I was from another planet at first, but they must have been hungry because they nodded and, as if on cue, my husband walked in the back door. Dinner could be served.

Together, and after introductions, we sat around our kitchen table, all of us tucking into the stew and home-baked bread. We spoke about their walk, about Dulverton and about how, once upon a time, I'd been lost, like them, with two young and very tired children. We, too, had walked for hours until we'd come to a road. Not recognising it, we slowly walked down a very long and dusty farm track and knocked at the door. A dog had barked from inside and the door opened. I was met with a grumpy and extremely unhelpful farmer, with mud on his trousers and black wellington boots still on his feet. I asked for directions back to the car park where I'd left the car; he looked at my children and grunted something about turning left out of the drive and to keep walking. The sun had gone down, we'd had no dinner, having been wandering in circles for around two to three hours, and it was growing dark. Yet there was no offer of a lift, of a drink or of kindness. It was another hour, carrying one of my

children along desolate, pine-tree-lined roads, before I eventually found our car, waiting for us where I'd left it. I've never been more happy. I vowed then that should anybody knock on our door, having found themselves lost, I would never treat them like that man had treated us.

Another cup of tea, and our visitors climbed into our truck, finally wending their way back to Dulverton, happy, warm, dry, fed and watered. Very grateful thanks had been exchanged, goodbyes said and I stayed at home to clear away the dinner things, content that I'd helped someone in trouble.

As I moved to and fro, following the well-worn path from the table to the sink and back, I pondered the impulse that had resulted in this evening's rescue mission.

We don't do acts of kindness for thanks or gratitude but simply because it's the right thing to do, to give help where help is needed, and to treat people how we'd like to be treated ourselves. After all, none of us know what's around the corner or when we're going to need help, too. Anyone banging on our back door, finding themselves lost, would be treated the same.

As long as we are here in this cottage, our porch light will shine out, a beacon of safety, inviting lost, weary walkers to shelter, a hot fortifying drink and sustenance. It's our Exmoor way; it's my mum and dad all over again. There's a saying: 'What goes around, comes around.' Hmm … I often wonder where that farmer's life took him.

About the Author

Ellie is the wrong side of sixty (her own words). She is married with two grown-up children, loves to be outdoors, and now lives on Exmoor with her husband. Originally moving to Somerset in 2004, she began writing thoughts about her life on the moor around 2013, a year before her youngest grandson was born. She felt that she needed to start a diary of sorts: in this way all three of her grandchildren would be able to learn what her life was like on Exmoor. Not having that kind of information about her own parents or grandparents, it spurred her on to making a record for them, so that they, too, would fall in love with the place where she lived. Writing from her Exmoor cottage, a cup of lemon-and-ginger tea to hand, together with a slice of homemade cake, Ellie knows that she has come home.

Acknowledgements

My husband accompanies me when we are out and about or simply working in the garden. He's less available when I'm cooking, although he does appear when it's tasting time. It is mostly thanks to him that we have some wonderful photos to bring my words to life; he is a diamond and also the glue that holds me together when my confidence fails me.

I must thank the custodians of the cottage whence I've penned my stories. They know who they are. The cottage is the heartbeat of my words and without its presence, and their understanding, I may not have started writing at all.

I cannot go forward without mentioning the inimitable Johnny Kingdom. He was an inspiration to my husband and me as well as a good friend. The kindness he showed, and knowledge he imparted, is everlasting.

My final thanks go to Olli at Blue Poppy Publishing. Thank you for seeing something in my words that others couldn't or wouldn't. You have made me smile, jump up and down, and cry, all at the same time, and I cannot thank you enough for giving me the chance to have a book published for my three amazing grandchildren; your help has been priceless. Sink or swim, it will be a legacy left for them, for always.

About Blue Poppy Publishing

Blue Poppy Publishing is a small independent publisher with big ambitions. It started in Ilfracombe in 2016 when Oliver Tooley wanted to give his self-published novel an air of credibility. The name was inspired by Oliver's grandfather Frank Kingdon-Ward who famously collected the first viable seed of *Meconopsis betonicifolia*, the Himalayan blue poppy. It now has dozens of titles by twenty or more authors but still has a way to go to compete with the big guns.

As a small business we depend on word-of-mouth far more than others so please, if you have enjoyed this book tell others, write a review, blog about it, post on social media.

This book is the first in a four-part series, with one title for each season.

Exmoor Tales – Winter is scheduled for publication November/December 2022. Exmoor Tales – Spring will hit shops in March 2023 and then Exmoor Tales – Summer will be available in May.

If you enjoyed reading about Exmoor in Autumn then why not add the remaining three books in the series.

Each volume includes many more stories of life on Exmoor, accompanied by more stunning full-colour photography.

Winter ISBN: 978-83778-002-0

Spring ISBN: 978-83778-003-7

Summer ISBN: 978-83778-004-4

Order from all good UK bookshops, or direct from www.bluepoppypublishing.co.uk